Klee

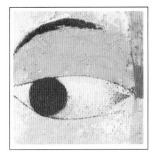

THE LIFE AND WORKS OF

KLEE

Linda Doeser

A Compilation of Works from the
BRIDGEMAN ART LIBRARY

SIENA

Klee

This edition first published in 1995 by
Parragon Book Service Ltd
Units 13-17 Avonbridge Industrial Estate
Atlantic Road
Avonmouth
Bristol BS11 9QD

ISBN 0 75251 195 5

Printed in Italy

Editors: Barbara Horn, Alexa Stace, Alison Stace, Tucker Slingsby Ltd and
Jennifer Warner.
Designers: Robert Mathias and Helen Mathias
Picture Research: Kathy Lockley

The publishers would like to thank Joanna Hartley at the
Bridgeman Art Library for her invaluable help.

PAUL KLEE 1879-1940

Klee

PAUL KLEE WAS BORN on 18 December 1879 in Münchenbuchsee, near Bern in Switzerland. As a little boy, Klee loved to listen to his grandmother's fairy tales, many of which she illustrated herself. He soon became interested in drawing and painting – but always fantasy, never from nature. His grandmother's death when he was only five years old was a sad blow; he described himself as 'left behind, an orphaned artist'.

He drew constantly, often fantastic and satirical drawings in the margins of his exercise books. In the holidays he began making pencil drawings of landscapes with painstaking accuracy and subtle shading.

In September 1898, aged nearly 19, he set off for Munich to study art. He presented himself at the Academy, but was advised to attend a private art school first. He joined Knirr's school and produced several nudes and portraits. Klee met Lily Stumpf, a pianist, in the autumn of 1899 and his affections became fixed. They were not to marry, however, until some years later.

The first steps towards the movement that later became known as Expressionism were being taken at this time. It is noticeable that Klee's landscapes changed, losing their objectivity and becoming more monumental and romantic.

In the autumn of 1901 Klee went to Italy with sculptor Hermann Haller. They travelled to Genoa, Naples, Rome and Florence. The trip was a revelation. Naturally, Klee explored the artistic treasures of Italy. He was impressed by the mosaics of early Christian art, Renaissance architecture and the works of Michelangelo. He was also strongly influenced by the international Gothic as manifested by Fra Angelico. During this trip, apart from the profound visual and aesthetic influence

of Italian painting, Klee underwent a deep revision of all his beliefs and theories about art.

Klee did not return to Munich but went back to Bern. He worked hard to complete his studies, which culminated in a series of 15 highly detailed, satirical etchings. From time to time he visited Munich and during one of these trips, in 1904, he encountered the works of Beardsley, Blake, Goya and Ensor. The influence of Goya, in particular, was extremely powerful.

In October 1906 Klee returned once more to Munich to marry Lily Stumpf. A son, Felix, was born in November 1907. At this stage, his career, like that of many young artists, was a mixture of 'successes' and 'failures'. During this period, his lifelong fascination with the line and tonality was consolidated. This is particularly apparent in the 25 illustrations that he drew for Voltaire's *Candide* in 1911 and 1912. Meanwhile, 56 of Klee's works were exhibited at the Berne Museum, the Zurich Kunsthaus and in a gallery at Winterthur. In 1911, he made the acquaintance of Kandinsky and other artists of the group known as Der Blaue Reiter (The Blue Rider). Klee believed that they shared a deep-rooted impulse to transform nature into a spiritual and pictorial equivalent.

An even more influential meeting with Robert Delaunay took place in Paris in April 1912. Delaunay gave an equal and independent importance to colour, light and movement in his work.

In short, Klee was at this time in close contact with most of the experimental artists of western Europe, many of whom were deeply interested in the question of colour. This preoccupation was further developed on a trip to Tunisia in 1914. The brilliant colours and strong light crystallized Klee's ideas about colour and tones.

Then, life was interrupted by World War I, during which Klee served as an officer. Although he produced some work during the war, he did not begin painting seriously again until 1918. By this time he was becoming well known. In 1919 he signed a contract with the art dealer Goltz who hosted a major exhibition of Klee's works in 1920.

On 25 November 1920, the architect Walter Gropius invited him to

join the Bauhaus group. So, in 1921 Klee moved from Munich to Weimar to take up his role of Master of Form in the glass shop. For the next decade, Klee taught at the Weimar and Dessau Bauhaus institutes.

Besides increasing recognition and a number of exhibitions within Europe, Klee's work crossed the Atlantic and was exhibited in New York for the first time in 1924. In 1931, Klee left the Bauhaus and was appointed to the Düsseldorf Academy. The Bauhaus, meanwhile, had been forced by the Nazis to leave Dessau and settle in Berlin. In 1932, Klee was violently attacked by the Nazis and, approaching Christmas that year, he returned to Bern, where he developed his final artistic phase, based on a desire for simplicity. He now also found himself close to penniless, his German funds having been confiscated.

His works from this period are much larger with a fine linear quality and bold graphic strokes. In 1934 his first English exhibition took place and a large retrospective was staged in Berne in 1935. In the same year, he developed the first symptoms of skin cancer. For some time he suffered depression as result of his illness, but in 1937 he resumed work with phenomenal drive and energy. Meanwhile, in Germany, some of his works were exhibited in a an 'exhibition of degenerate art' and a further 102 were confiscated from public collections.

On 10 May 1940 Klee was admitted to a Sanatorium near Locarno and was transferred to the Sant' Agnese Clinic less than a month later. He died on 28 June.

NOTE
Klee experimented with mixing media, using watercolour and oil paint together or paint, glue and varnish, for example. It is not always possible, therefore, to specify the medium for some works.

▷ **Garden Scene with Watering Cans** 1905

Watercolour sous verre

THROUGHOUT 1905, Klee was experimenting with tonality and light. This work, typical of the period, contrasts densely painted areas with a finely detailed background. The brightness of the white light, which seems unreal and unsatisfactory, clearly demonstrates Klee's difficulties at this time, when he was attempting to find a means of expressing purity of form, his understanding of nature and his own inner world. It was during this year that Klee travelled to Paris with his friend Louis Moilliet, but he was surprisingly unenthusiastic about the work of the Impressionists who had, in fact, tackled precisely the problems of tonality and light that Klee himself faced. In his diary he wrote, 'I have nothing to learn from the French,' and did not revise that opinion for some years.

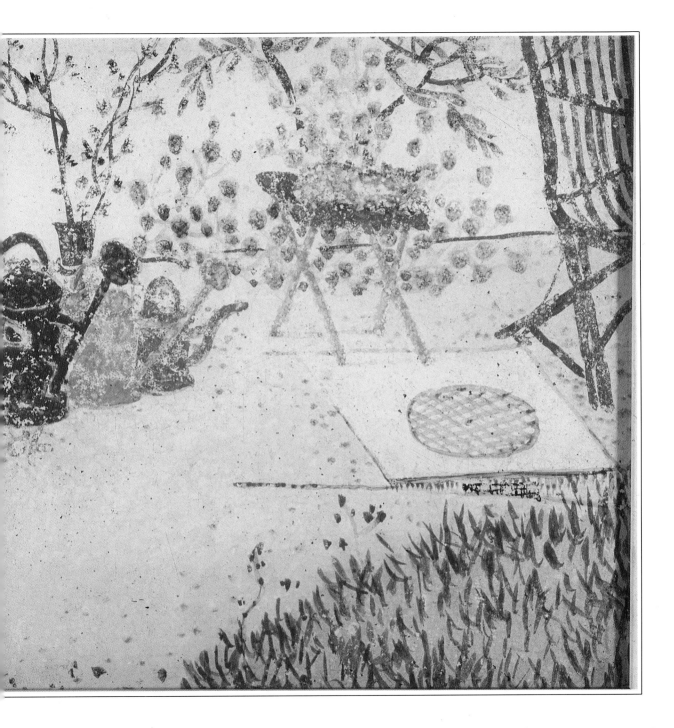

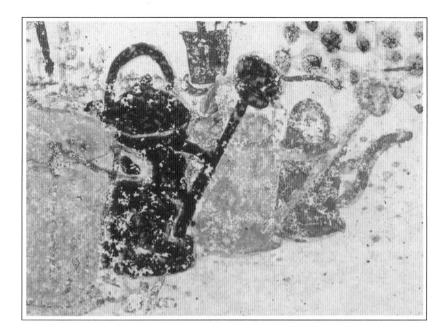

△ **Garden Scene with Watering Cans** (detail)

THERE IS LITTLE in this charming painting to indicate the great and innovative artist that Klee was to become. Throughout his life he took pride in his draughtsmanship and this skill is already apparent. There are, too, signs that point towards his desire to express the mobility of light, but at this time he had still to experiment with and explore the use of colour. His mastery of tonal values was a long journey away. The play of shapes of the cans and bucket clearly gave him pleasure, but gives no indication of the extraordinary spatial awareness that he would later show.

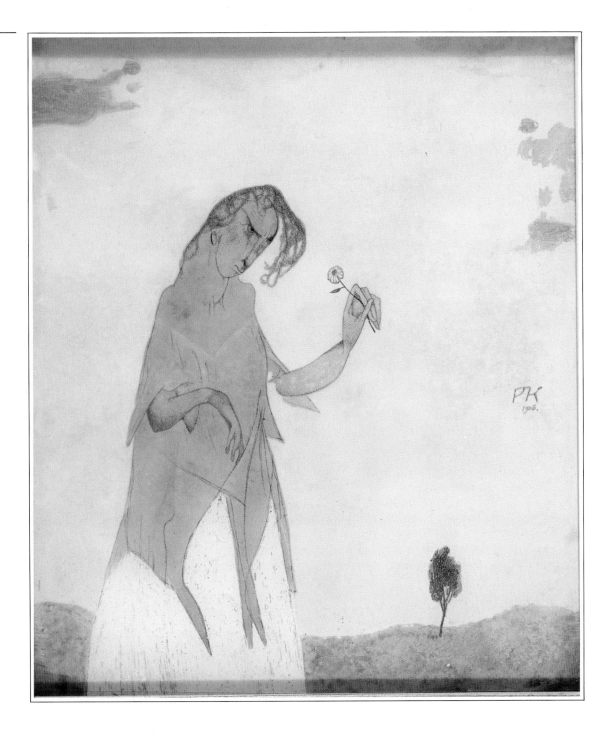

Sentimental Girl Considering her Love 1906

◁ *Previous page 11*

IT IS, PERHAPS, no coincidence that this was painted in the year in which Klee married Lily Stumpf whom he had met in Munich in 1899. It is also interesting that Lily had particularly striking eyes and fine brows. By this year, Klee's interest in and control over the line was strongly developed and his confidence in handling tonal values was greatly increased. He was maturing, both as an artist and as a man, and, while he had not yet reconciled the worlds within and without, he was undergoing a process of allowing his art and imagery to develop from himself.

▷ Garden Still Life 1910

Watercolour

KLEE CONSTANTLY experimented with ways of handling tonality and form in these early years and was more concerned with what he thought of as 'pictorial discipline' than with specific results. The year before he painted this work he had spent many months working at ways of harmonizing form with areas of colour. He had been concentrating on monochrome uses of colour, working mainly in shades of grey. By 1910, he was using graduated tonal values of colour spatially, rather than grey, but he was continuing to work on a basically pictorial, rather than inner or spiritual, approach. He controlled his inclination to impose his knowledge of line and draughtsmanship on his use of colour in an emotionally impelled and abstract way by further use of line at the final stages of the painting.

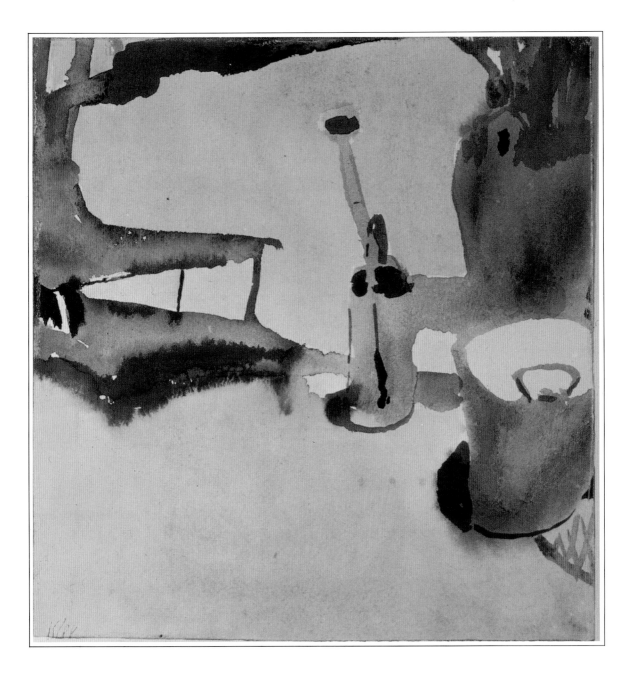

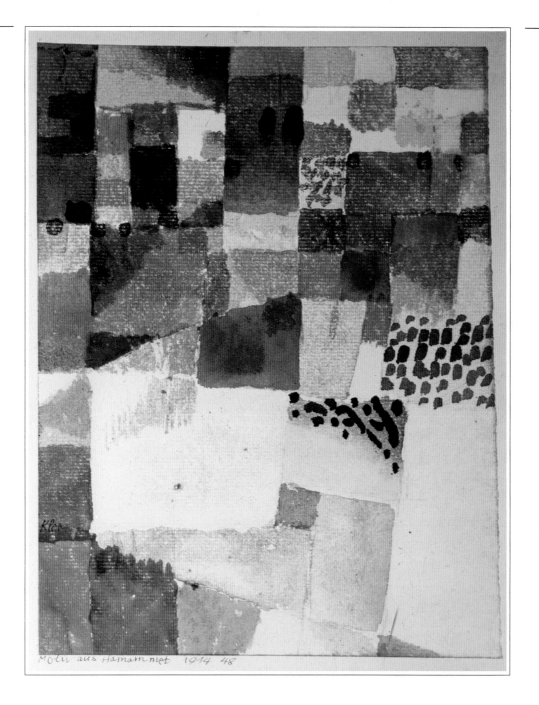

◁ **Motiv aus Hamammet** 1914

Watercolour

THE BROAD, ALMOST CARELESS brush strokes, a rectilinear use of space, the flat areas of colour and the apparently simple design elements of this work show the powerful influence of Robert Delaunay at this stage in Klee's life. The way he used colour, light and spatial tonality also reflects the deep impressions made upon him by his seminal visit to Tunisia in April 1914. A geographical and spiritual journey – he questioned himself in his diary, 'My real country?' – this trip to northern Africa profoundly affected his concepts of simultaneity of line and tonal contrast.

△ **Motiv aus Hamammet** (detail)

IN THE WATERCOLOURS Klee produced following his visit to Tunisia he temporarily abandoned his theories about line; form virtually results from colour. There is a new air of confidence in the use of broad strokes and thick paint and, indeed, in his diary Klee recorded a more mature feeling of self-confidence than his earlier record of something more closely resembling bravado. He also wrote, 'I am possessed by colour – I do not need to pursue it. I know that it will possess me for ever. This is the great moment; I and colour are one. I am a painter.'

▷ **South Wind in Marc's Garden** 1915

Watercolour

KLEE REMAINED LARGELY detached from political events throughout World War I. Of course, it must be remembered that although German by descent, he had spent his childhood and youth in Switzerland. He was granted a passport to visit his family in Switzerland on condition that he returned to Germany. His response was, 'What would I be without Germany?' His friends and colleagues had dispersed, either into the army, like Franz Marc, or elsewhere, like Kandinsky who had returned to Russia. Throughout the war Klee was cut off from the exciting influences to which he had been exposed previously, but some elements of Cubism can clearly be seen here, although the sombre tonal values are very much Klee's own.

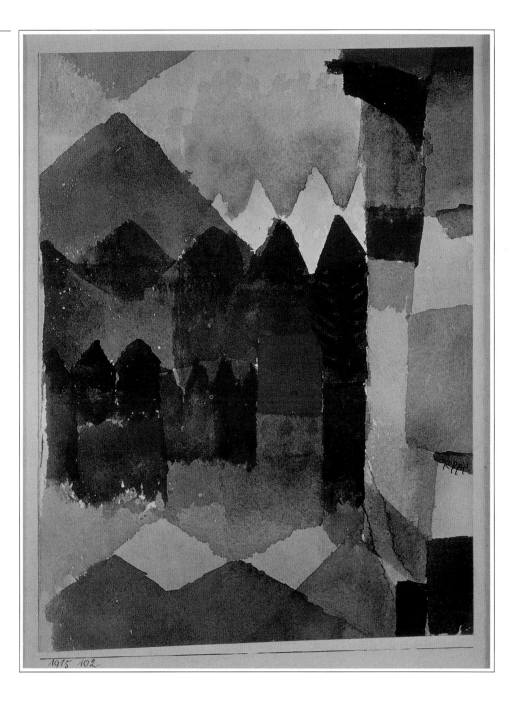

1915 102

▷ **Der Fisch im Hafen** 1916

Watercolour and ink

FISH AND OTHER MARINE
creatures became a *leitmotiv* in
Klee's work from the time he
visited the Dohrn aquarium at
Naples. Here, a luminous,
almost abstract use of colour is
combined with expressive,
dynamic line to synthesize
Klee's inner reality. The
dramatic tension of the image,
with its sense of movement
held closely in check, is
underlined by this
counterbalancing technique of
powerful washes of colour and
sharp, staccato lines.

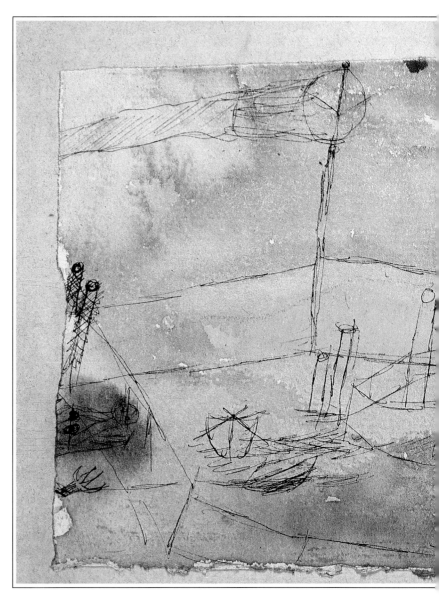

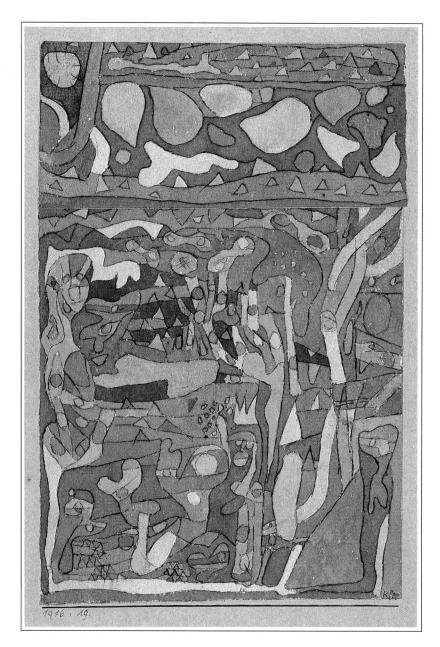

◁ **Miniature** 1916

THE CURVED, dynamic shapes of this abstract have an almost three-dimensional quality as a result of Klee's use of both sharply contrasting colours and closely associated tones, particularly of green. The strong influence of north African primitive art is clear, not least in the apparently random juxtaposition of shapes suggestive of tribal carvings and masks. Much of the composition includes sinuous lines and figures with a serpentine quality and it is interesting that the snake assumed a pictorial and symbolic importance as an image in Klee's later work.

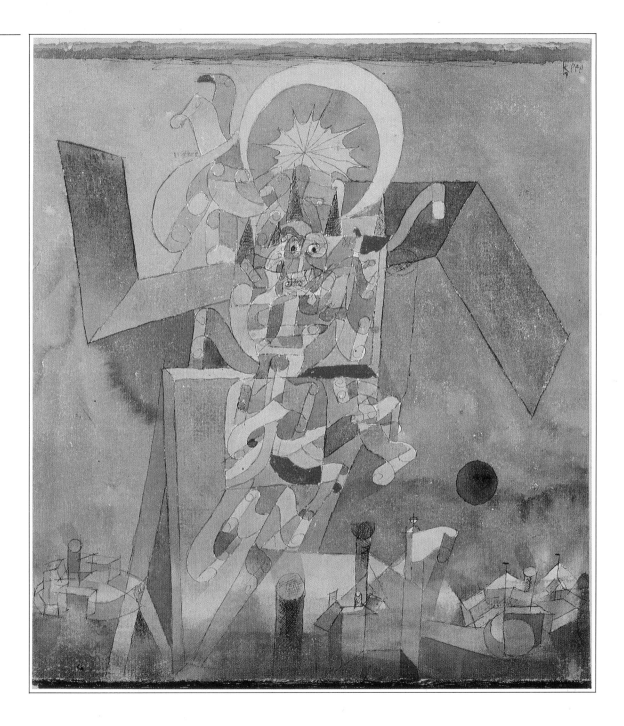

Demons on the Boats 1916

Watercolour

◁ *Previous page 21*

KLEE'S MILITARY SERVICE seems
not to have been very arduous
and he was, in any case,
determined not to allow war to
interrupt his work. After he
was posted to Gersthofen time
would have hung heavily on
his hands had he not
developed an interest in
Chinese poetry. This dream-
like evocation, with its oriental
overtones, may have been
partially inspired by his
reading of this verse.
Throughout his life, Klee drew
on all his experiences to
express his vision. The
abstract, writhing shapes have
a dynamic quality further
enhanced by the contrasting
use of colour.

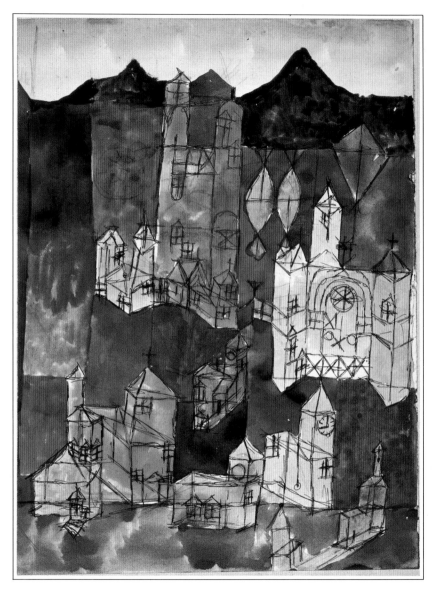

◁ **Stadt der Kirchen** 1918

Watercolour

SHARPLY DRAWN LINE is imposed on broad areas of deep colour in a way that is strongly reminiscent of the works of Cubist painters. The use of colour is central to this painting of a 'town of churches'; the glowing, brilliant red, in particular, entirely intentionally recalls the jewel-like clarity of stained glass. Klee's experiments with colour have sometimes been underestimated or dismissed in a rather offhand manner. He mixed media – oils with tempera or watercolour, glue and varnish – and explored the potential of Chinese ink and the use of black (if that can be said to be a colour). He can, justifiably, be said to be one of the greatest colourists of 20th century art.

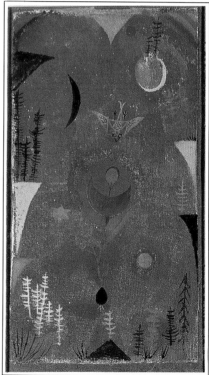

▷ **Blumenmythos** 1918

BY THE TIME THE Armistice arrived Klee's poetic, pictorial style had become fully coherent – a fusion of his inner, spiritual world and the outer world of nature. This finely balanced work includes symbols that recurred in many of his paintings of this period: the spiky, coniferous trees and crescent moon, for example. The contrast between the curved and rounded shapes of the central flower image; to which the viewer's eye is immediately led, and the sharper, more geometric images surrounding it is disturbing and, paradoxically, simultaneously suggests an overall harmony of vision.

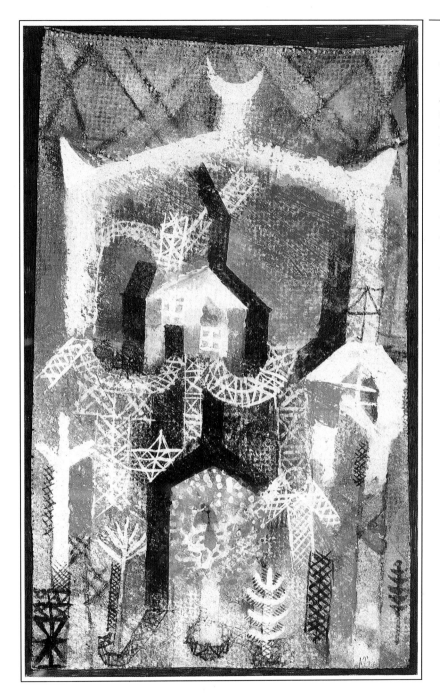

◁ **Gartenbild** 1919

A SUBTLE USE OF pastel colours and graphic white lines provides a sense of the three-dimensional. There is an expression of dynamic tension between the natural world and the man-made which reflects Klee's concern to express the balance between his inner vision and outer existence. During this time, Klee was at work on *Schöpferische Konfession* (Creative Confession), a series of essays on art – his own and that of other contemporary artists. In it he wrote, 'Art does not reproduce the visible; it renders visible'.

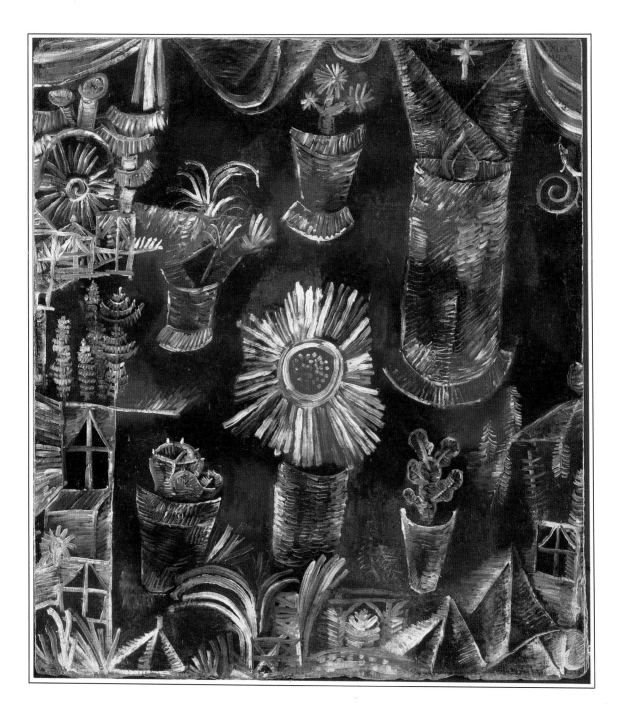

Stilleben mit der Distelblute

◁ *Previous page 25*

THE PROCESS OF harmonizing his architectonic sense and his understanding of the lyrical was prolonged for Klee. In some ways this is one of his most naturalistic works, produced during his long quest to discover the nature of light and understand the nature of visibility. In nature, things are visible only when light is reflected by them. It has been argued that they have existence only when visible through the reflection of light and therefore are perceptible, so that external verification of their existence can be made.

Klee found this phenomenon fascinating and struggled with various media, including *sous-verre*, in search of a valid means of expressing this concept. The sense of light in this work is rich and pervasive, although Klee's palette is subtle and quite limited.

▷ **Abstract Composition of Houses**

KLEE WAS IMMENSELY excited by the works of Cézanne, particularly by the way in which he used colour. He was also influenced by Cézanne's belief that geometric forms are the basic forms of nature. This abstract composition bears testimony to Klee's debt to him and suggests that he was familiar with Cézanne's pronouncement, 'Nature is not only on the surface, but also in depth; colour is the expression of this depth on the surface, and has its roots deep in the world.'

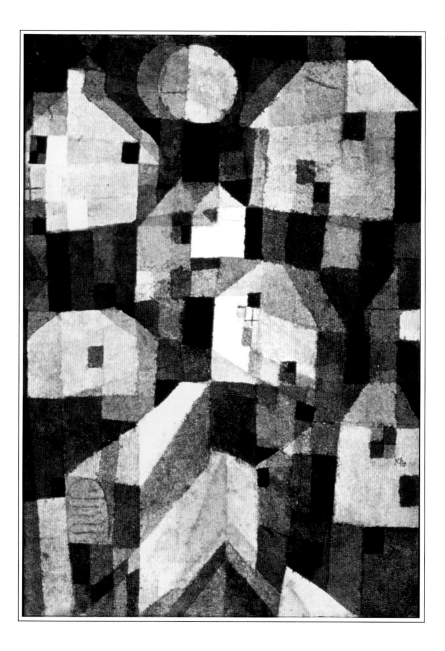

▷ **Das Lamm** 1920

KLEE WROTE 'symbols comfort the spirit' and was deeply concerned with what he called the 'mystery' of art in a quasi-religious sense. He believed that 'the visible is only an isolated case and that other truths exist latently and are in the majority'. The lamb is a Christian symbol, as, of course, is the cross. The invisible is here literally made visible by the artist, partly through his use of line and, more subtly, through tonal variation of colour. The gradation in tone – a chromatic approach (a word Klee himself advisedly used) – is a reminder that Klee was a talented and informed musician. However, it should not be assumed that he was attempting to reproduce musical form in the plastic arts.

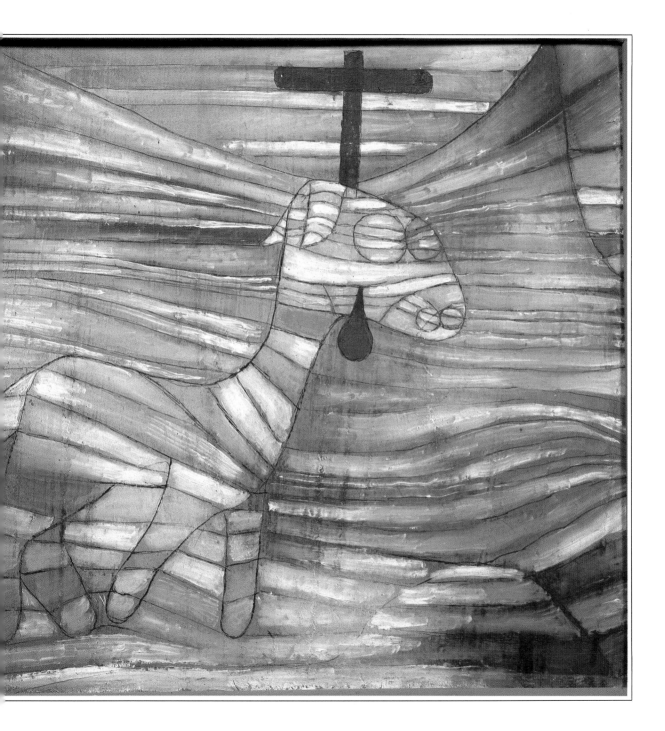

▷ **They're Biting** 1920

THIS WORK SHOWS Klee developing in a further direction and demonstrates his perfect control over pure line set against a subtly toned background. He readily adopted Braque's technique of including letters or numbers in his work and De Chirico's inclusion of arrows. This appealed to his highly developed poetical pictorial sense and here he felt impelled to include an exclamation mark – a symbol that has no equivalent in any other form – almost at the centre of his painting.

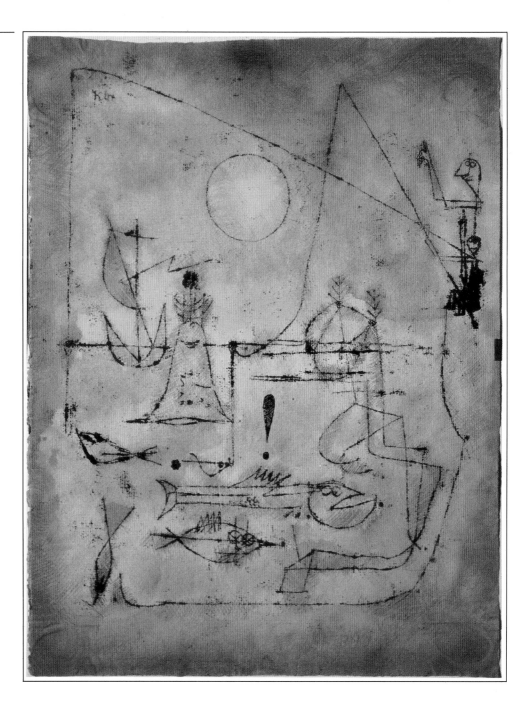

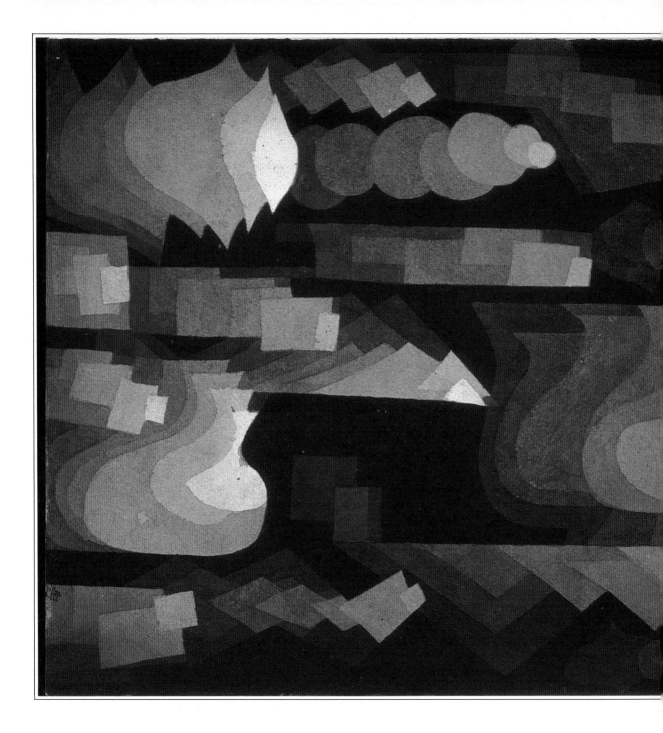

◁ **Fuge in Rot** 1921

A FUGUE IS A polyphonic musical form in which a main theme is established and then developed and harmonized contrapuntally. Arguably the greatest exponent of the fugue was Bach, one of Klee's favourite composers and one with whose works he was very familiar. Here the fugue is visually developed in the form of clearer tones of colour gradually emerging from a dark background, passing through shades of grey and eventually becoming the palest of pinks. The curved and circular shapes offer a counterpoint to the rectilinear and more geometric shapes.

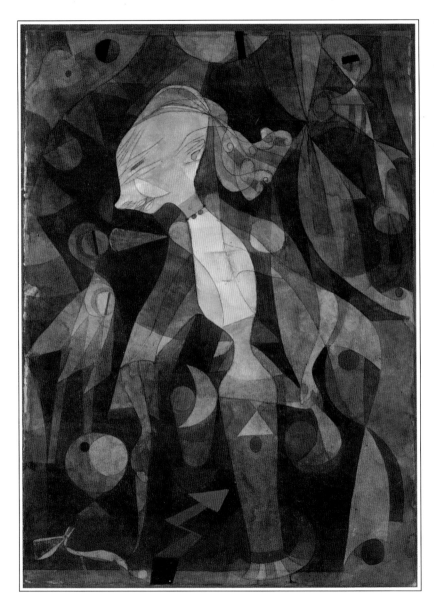

◁ **A Young Girl's Adventures**
1922

WALTER GROPIUS had invited Klee to joint the Bauhaus group in 1920 and, in his teaching, Klee laid great emphasis on form and colour. This painting is virtually a classic manifestation of his theories. Like Kandinsky, who, by this time, was also a member of the group, he constantly emphasized the importance of form – planes, the use of space, surface and line – and this is apparent in the almost monochrome structure of this composition. The startling use of scarlet is also reminiscent of Kandinsky. However, Klee's approach to art differed in his belief in a pictorially, rather than constructionally driven impetus. Thus, although he rejected ready-made forms, he still looked to the external world in order to disassemble and then reassemble it as an expression of his internal world.

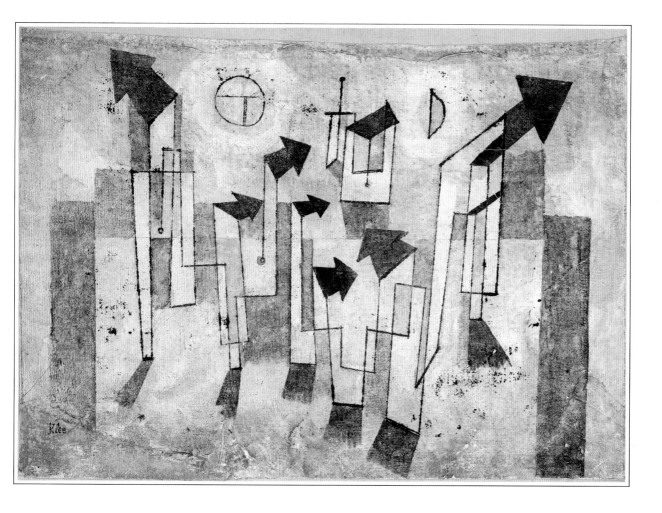

Wandbild aus dem Tempel der Sehnsucht Dorthin 1922

◁ *Prevous page 35*

KLEE CONTINUED HIS SEARCH for ways to express a synthesis of external vision and internal contemplation in this far more abstract work. A superb draughtsman, he was naturally drawn to abstract expression. The subtle use of colour suggests a three-dimensional quality, further emphasized by architectural forms. The deliberate imbalance and lack of equilibrium is powerfully accentuated by the use of the heavily drawn dark arrows. The circle (sun) and crescent (moon) images recur in many of Klee's paintings.

▷ **Senecio** 1922

Oil on linen

THIS CHILDLIKE, although not childish image is dominated by the two eyes that stare out of the painting at the viewer. Hardly surprisingly, eyes were a subject to which Klee gave considerable thought. He wrote, 'All these paths meet in the eye and from that point, being translated into form, lead to synthesis of external vision and internal contemplation'. He also wrote, ' Plastic art was born of movement, is itself caught and held and is registered in movement (eye muscles)'.

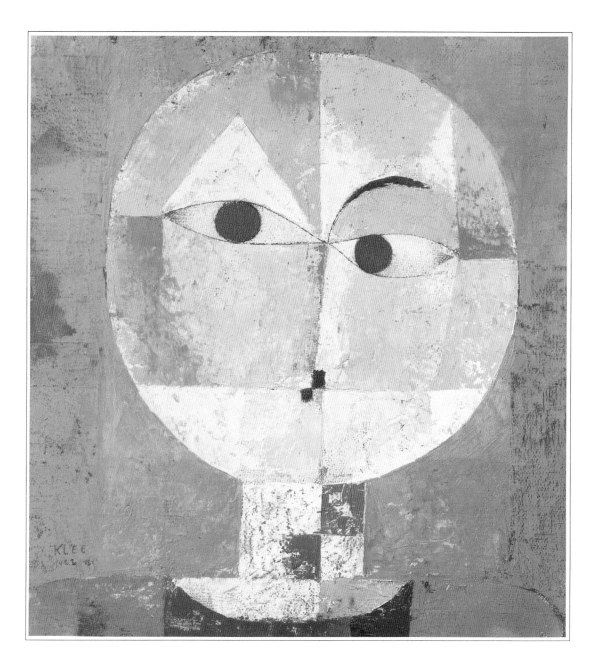

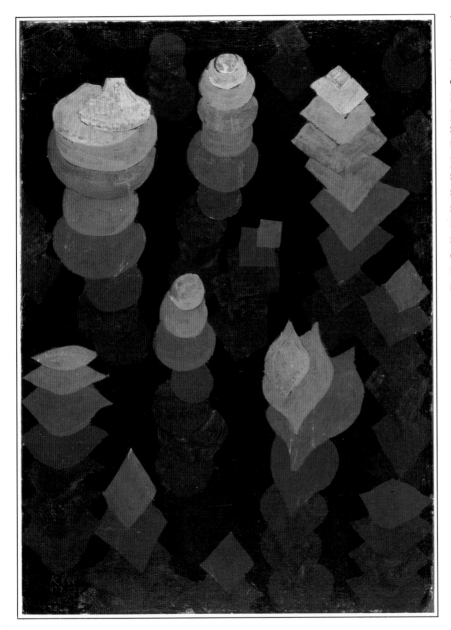

◁ **Growth of Nocturnal Plants**
1922

NIGHT AND THE QUALITY of
dreams inspired and
fascinated Klee. These strange,
plant-like forms appear almost
submerged in the darkness in
the same way that submarine
plants are submerged by the
sea – another continuing
source of inspiration. They
seem mobile as we look down
into their depths, as if they are
swaying in the currents of
darkness as seaweed sways in
the tide. They have a strangely
sinister beauty.

▷ **Growth of Nocturnal Plants** (detail)

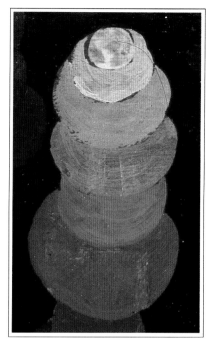

KLEE BELIEVED THAT the painter's role was to make the invisible visible. In this image of these strangely eerie plants he has a double task in showing the eye of the viewer that which it cannot normally perceive: growth and something nocturnal, that is, in the absence of light. This aim is achieved through the use of both colour and form. The unequal, yet balanced and rhythmic planes painted in close tones create a strong sense of growth. So too, does the use of increasingly brighter colour towards the top of the plants. This also has the effect of suggesting a kind of inner illumination that is independent of external light.

▷ Das Schloss

Watercolour

HERE KLEE WAS STILL using primarily a graphic means of expression against a rhythmic tonal background. He drew equally well with his left and right hand and placed great value on dexterity and manual skill. In this, he was fully in tune with the Bauhaus's approach to artistic education. Yet he never allowed his drawing to become semi-automatic and simply take over the composition. There was always a poetical essence and profoundly personal element in the process of creation. This delightful watercolour harks back to Klee's childhood when he and his grandmother illustrated the fairy-stories that she used to tell him.

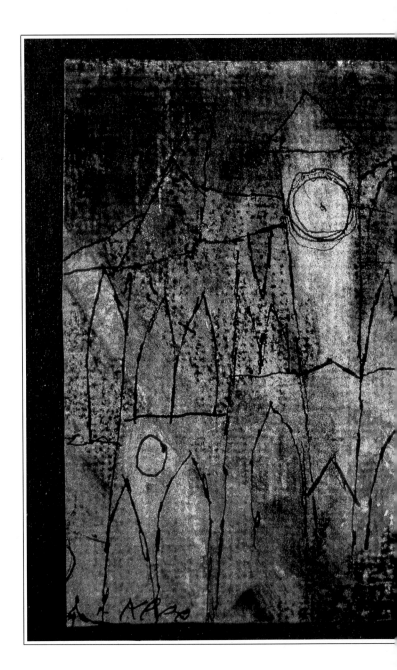

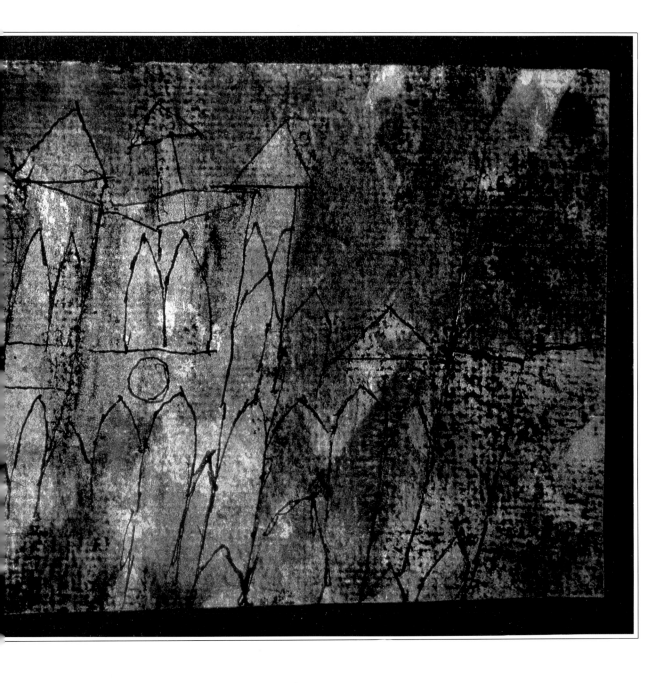

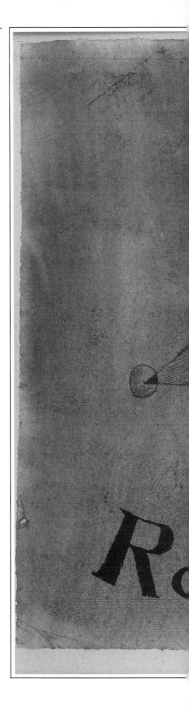

▷ **Rotation** 1923

THE SENSE OF CIRCULAR movement is powerfully conveyed in the economically drawn fine line and the 'ideogram' of a windmill. Adding letters or words to a painting was a favourite device and their positioning here emphasizes the sense of movement. Arrows, too, appear in a number of Klee's works – a device he adopted from De Chirico. In his *Pädagogisches Skizzenbuch* (Pedagogical Sketchbook), written mainly for his Bauhaus students and published the following year, he wrote, 'Movement is the basis of all becoming. When a dot becomes movement and line, time is involved – a work of art is built up piece by piece, just like a house'.

1923 134 Rotation

Klee

▷ **Still Life with Snake** 1924

Pastel

THIS IS, OF COURSE, anything but 'still'. The serpentine lines of the 'still life' and the strangely curling natural forms reflect the undulations of the snake. Later, Klee would play with the idea of using secondary lines to enhance, complement and counterbalance a primary line that was not, in fact, drawn and existed as only a concept in the way that the secondary lines here counterpoint and even confuse the line and movement of the snake. Line is very much the essence of this work with colour used for only subtle highlights.

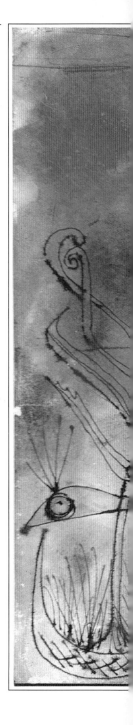

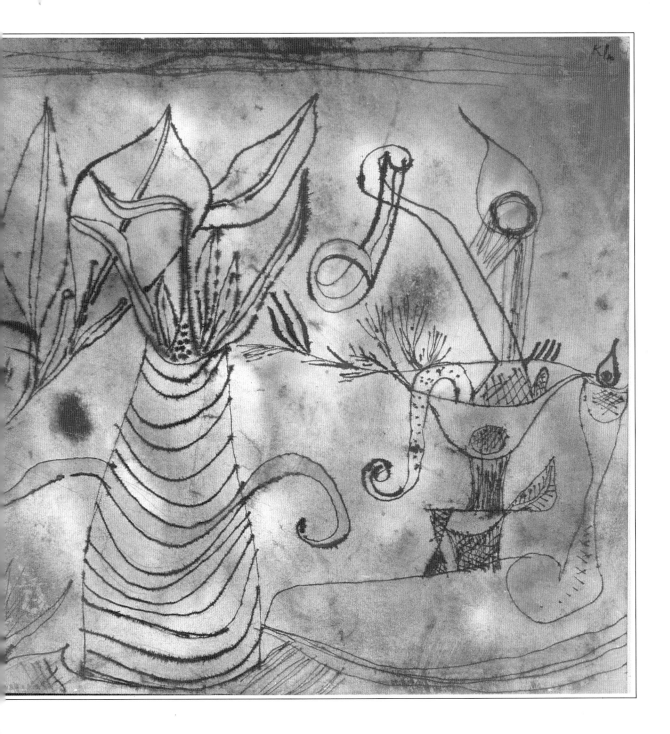

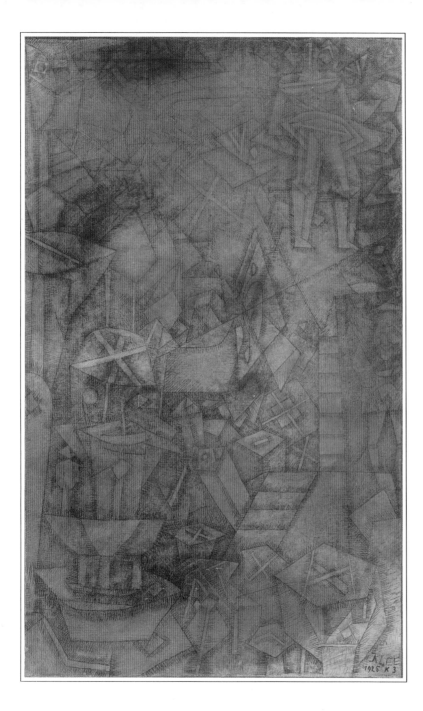

◁ **Buhneprobe** 1925

THIS WAS A DISTURBING and
exciting year for Klee as he
and the other Bauhaus
teachers and students settled
in Dessau, the Weimar school
having been forced to close in
December 1925. He had his
second large exhibition in
Goltz's gallery, he held a one-
man show in Paris and also
took part in the first
exhibition of Surrealist
painters in Paris, which also
included works by De Chirico,
Max Ernst, Miró and Picasso.
During this year he produced
a number of theatrical works,
including this subtly coloured
and complex piece.

△ **Buhneprobe** (detail)

A COUPLE OF YEARS EARLIER,
Klee had written: 'The further
he [the artist] progresses with
his vision of nature and with
meditation, the freer he is to
organize groups of abstract
forms, which go beyond the
schematic and the arbitrary
and achieve a new natural
order the natural order of the
work of art. Then he creates
a work or he participates in
the creation of works which
are images of the handiwork
of God.'

▷ **The Golden Fish** 1925

A 'GOLDEN' FISH rather than a 'goldfish', the underwater creatures that populated Klee's imagination were always extraordinary, notwithstanding the fact that aquatic forms often grotesquely defy the human imagination. This was at least part of their appeal to Klee. These luminous creatures make an almost formal pattern against the deep, underwater background filled with the semi-visible silhouettes of mysterious plants.

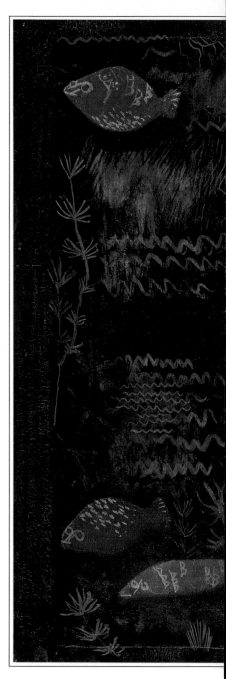

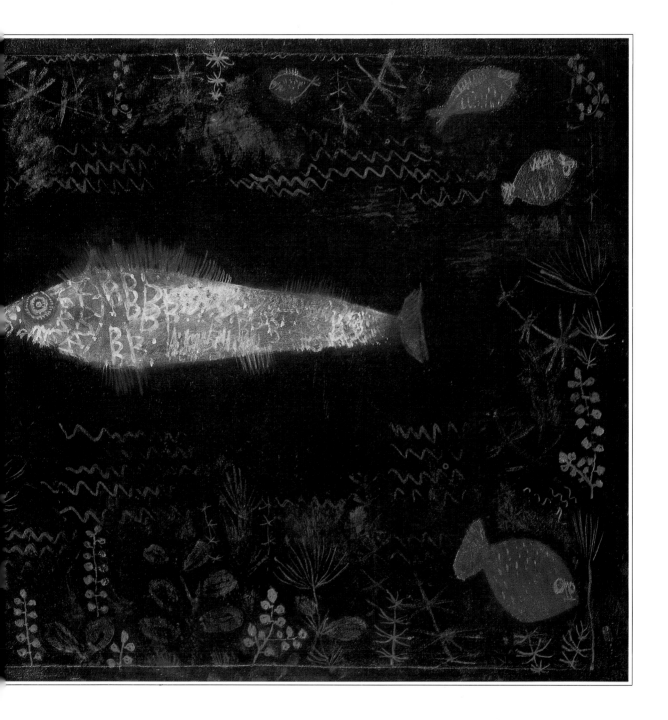

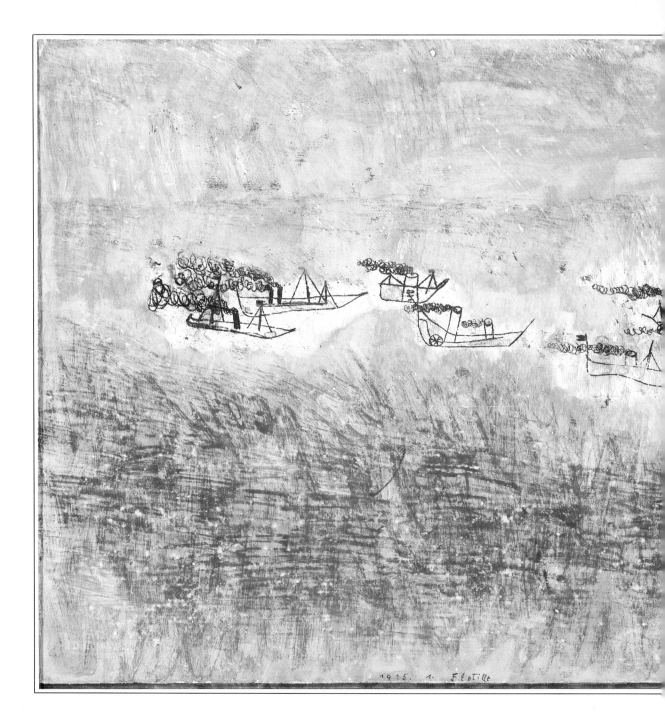

1925. 1. Flotille

◁ **Flotilla** 1925

KLEE HAD AN EXCEPTIONAL ability to look at the world from a different standpoint and here he has adopted a viewpoint reminiscent of that of a child. However, he deeply resented and passionately repudiated the suggestion of hostile critics that his work was childish. Both line and colour have a unique and arresting charm and purity. Movement, nevertheless, remains an important concept and there is a strong sense of this bizarre fleet steaming forward majestically and irresistibly, although maybe not always at the same speed and in the same formation.

▷ **Mystisch Keramisch** 1925

Oil on cardboard

THIS QUITE EXTRAORDINARY painting, with its textural and tonal qualities, is aptly named (the title translates as 'Mystic Ceramic'). At about this time, Klee stated, 'Formerly the painter depicted objects which were to be seen on earth, things he liked or would have liked to see. Now the real nature of visible things is revealed, so the belief becomes reality that, in terms of the universe, what is visible is but a fragment of the whole, there being many more latent realities. Things appear both magnified and multiplied, and often in contradiction with the rational experience of yesterday.' This is genuinely a mystic composition: the two ceramic containers form a unit, but is the face ceramic or human or, indeed, both? Two crescents (the moon was a constantly recurring symbol in Klee's work) edge the disc and the head. The impressionistic tree on one side forms an intriguing contrast. The whole is partially curtained as if glimpsed through a window or seen on the stage.

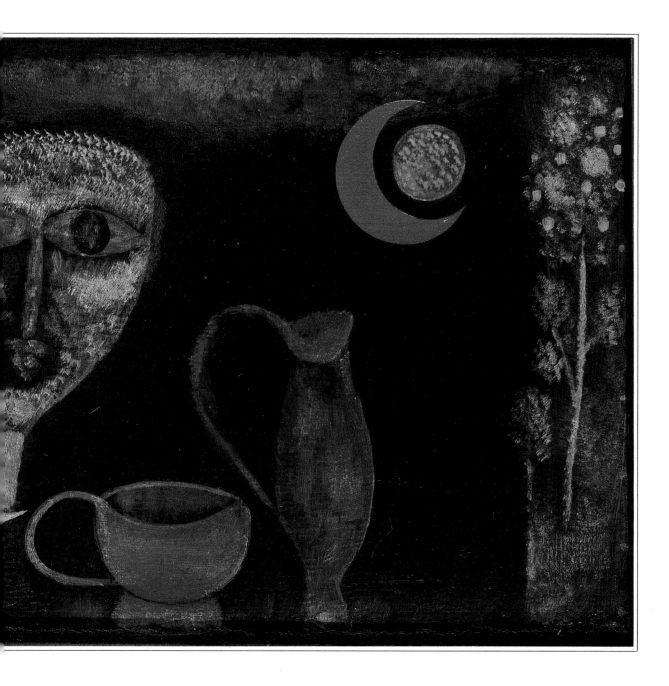

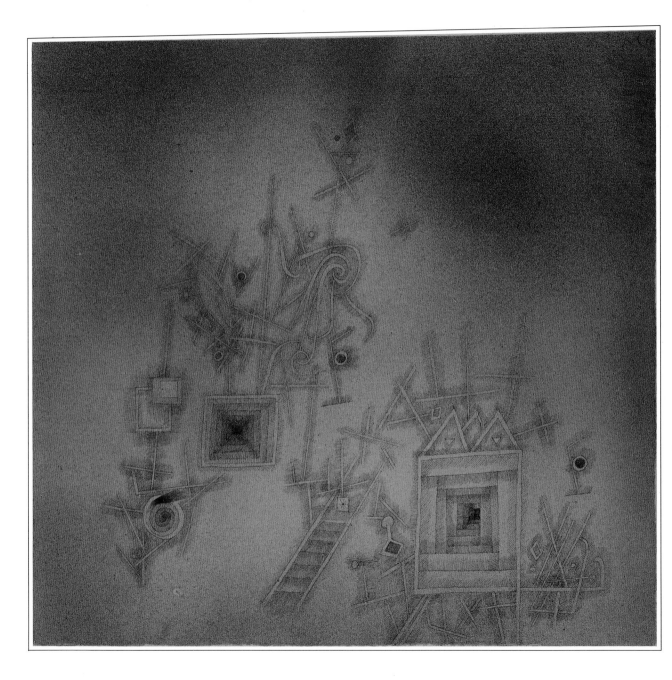

◁ Abstract Composition

EACH IMAGE in this drawing is closely connected with the next in a way that might be described as architectural. The rectilinear shapes have a solid, three-dimensional quality, while the elaborate, curly 'embellishments' have an almost animal mobility. The sureness and lightness of Klee's control over line is evident. Klee's universe is not so much a parallel one but rather an expression of his feeling that everything is part of a universal design and that this universal design is also part of everything. He constantly sought ways to express this sense of universal interdependence.

Mast und Zier Fische

▷ *Overleaf pages 56-57*

THE FLAT, YELLOW virtually silhouetted images give this painting its depth, whereas the brightly coloured fish seem to be swimming in the foreground. The composition – mirroring shapes and the spatial disposition – give this work its balance, creating the same extraordinary sense of tranquillity as gazing through the glass walls of an aquarium. The sea, ships, fish and submarine life are themes that permeate Klee's work. He developed his interest in painting variations on certain themes early in his career and particular subjects recur throughout – flowers and plants, gardens, the moon, night being just some of them.

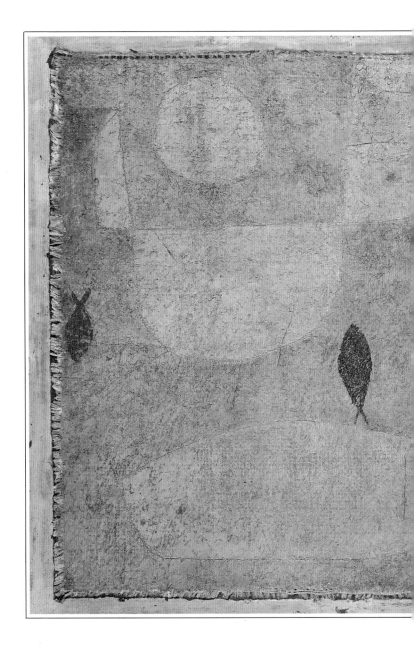

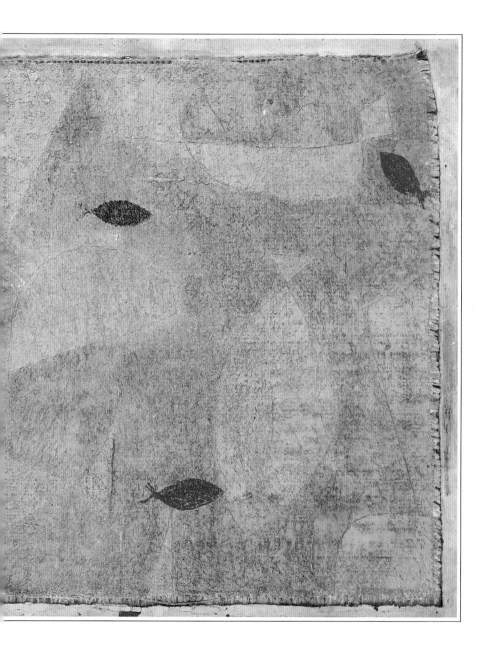

◁ **The Magic Garden** 1926

GARDENS HAD A SIGNIFICANCE to Klee throughout his life and featured in many paintings in many forms from *Garden Scene with Watering Can* (1905), through *Botanical Garden* (1926) and *Garden Rhythm* (1932) to *Underwater Garden* (1939). In addition, trees, flowers and other plants often appear in his paintings. The subtle use of pastel colours and lightly drawn graphic images give this particular garden its magical quality. The central image, like an ornamental statue is draped in trailing green and surrounded by carefully drawn and decorative symbols and counterbalanced by the startling deep blue circle of the pond.

▷ **Partie aus G.** 1927
Watercolour

IN THE PREVIOUS YEAR Klee
had visited several Italian cities
and in 1927 he went to Corsica
and also visited Avignon on his
way home. This delightful
painting has a distinctly
Mediterranean and southern
European feel. Although his
ancestry was German, Klee
always had a special affinity
with more southern countries.
The colour, composition and
viewpoint also give a slight but
rather pleasing impression of a
child's toy village built from
wooden blocks.

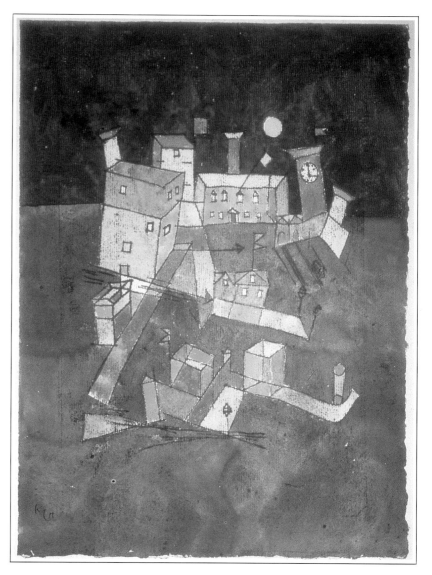

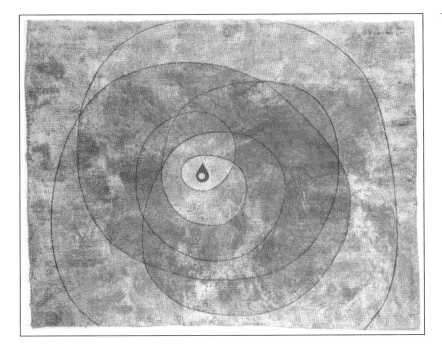

△ **Around the Kernel**

THIS APPARENTLY SIMPLE
composition leads the eye
through the 'layers' directly to
the 'kernel', the dark red
central image. However, the
outer 'layers', which at first
seem to be merely overlapping
ovals are, in fact, complex
spiralling shapes and it is
Klee's manipulation of tonal
values that creates the
harmony and rhythm. One of
the ways in which his
preoccupation with the
essential, inner nature of
things manifested itself was in
several paintings with figures
of pregnant women and it may
not be fanciful to link this
painting with them.

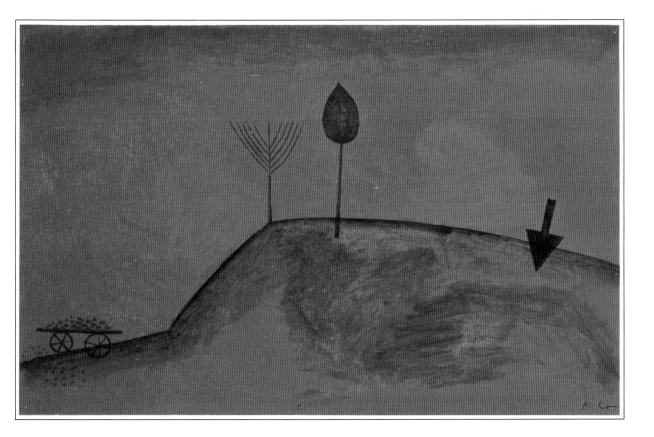

△ **Untitled** 1930

THIS UNPEOPLED, GLOWING landscape seems to suggest an almost intolerable sense of isolation. Its dreamlike or 'other world' quality is disturbing yet fascinating – the fiery red sky, the two strange and contrasting trees, the abandoned cart. The sense of isolation is further emphasized by its being an untitled landscape. Klee was a poetic man and his works usually had poetic and metaphorical titles that corresponded with their poetic pictorial content. He considered the choice of title extremely important and an integral, though usually final, part of the entire work. He referred to 'christening his pictures'.

▷ **Still Life with Casket** 1931

THE OBJECTS HAVE all been precisely arranged in formal patterns, but the painting is not in any sense a formal still life. As always, Klee searched for a means of expressing his inner vision and brought all his experiences to bear. The precise 'real' nature of the objects is not necessarily apparent and, indeed, is not particularly important. However, there are hints and suggestions of several of Klee's favourite forms, such as flowers and sea creatures.

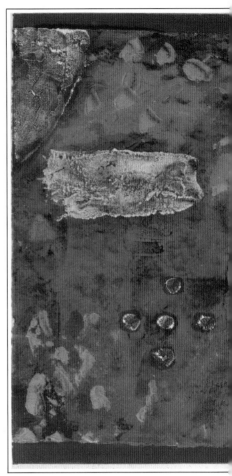

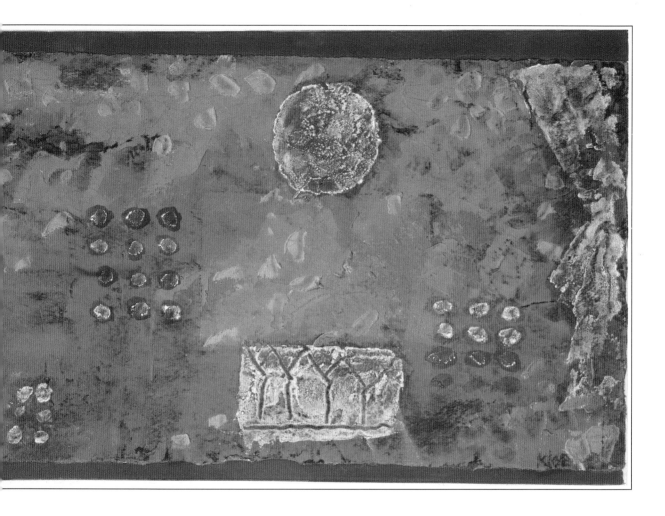

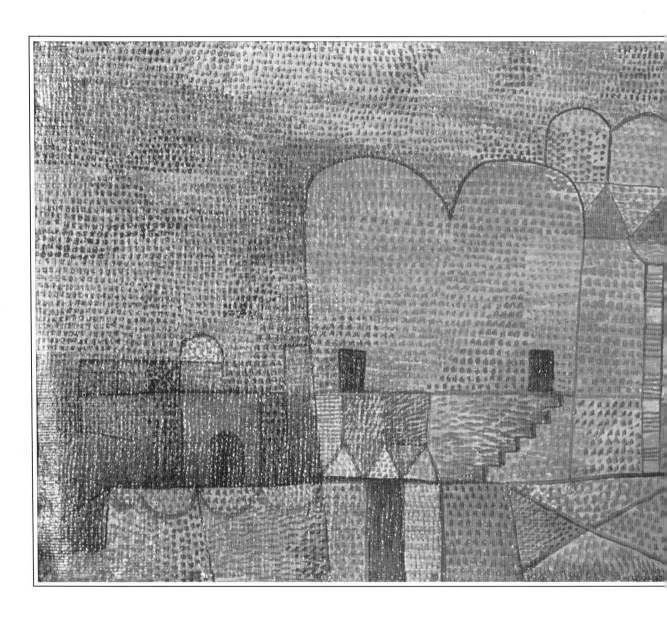

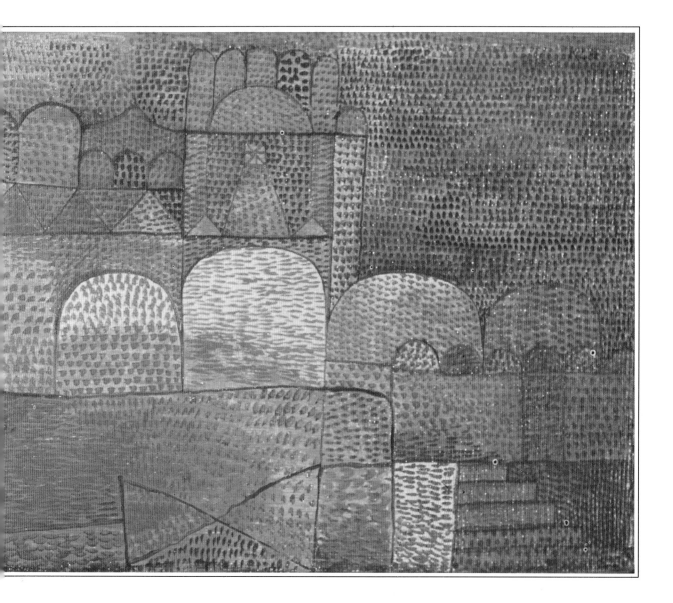

Kathedrale

◁ *Previous pages 64-65*

KLEE'S CLAIM THAT his visit to Tunisia was a visual revolution was no understatement. He produced a number of works in an almost pointillist technique. This approach and his sheer mastery of tonal values, as seen here, was wholly in accord with several aspects of his life and intellect. For example, he had been impressed with Byzantine mosaics on his first visit to Italy and this painting, not only in style, but also with its domes and towers, powerfully evokes these. There is also a strong textural aspect to this work reminiscent of a woven textile. Klee, of course, spent part of his early years with the Bauhaus group in charge of weaving.

▷ **Fabrikstadt**

THE PATCHWORK OF COLOUR and arrangement of lines in this abstract work demonstrates very clearly Klee's method of filtering external experience to create an inner vision. The regularity and uniformity of colour and shape and the threatening sense of claustrophobia as the painting seems to be trying to encroach on the space outside its frame, held back only by what might be seen as a wall, combine to make a powerful almost political comment on urban society. The viewer might even wonder whether the red triangles, apex pointing up, are symbols of hope or of hope shut out. One cannot help recalling how, as a child, Klee was mesmerized by the 'pictures' that he saw when gazing at the marble table tops in his uncle's restaurant.

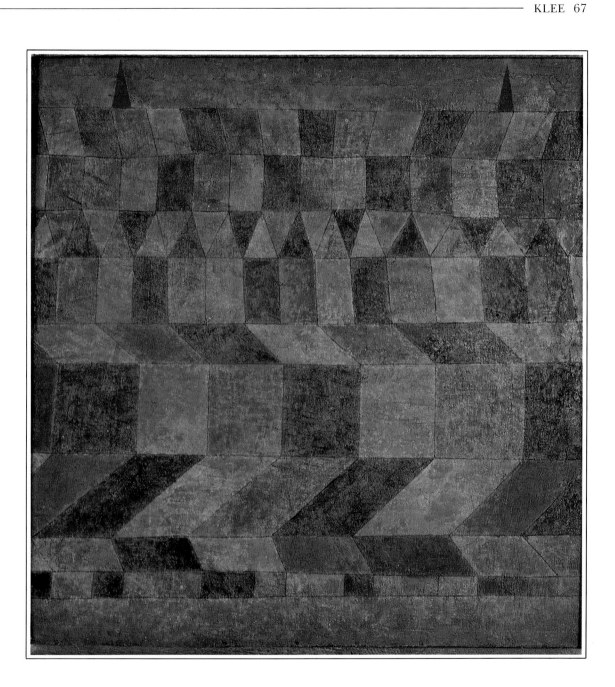

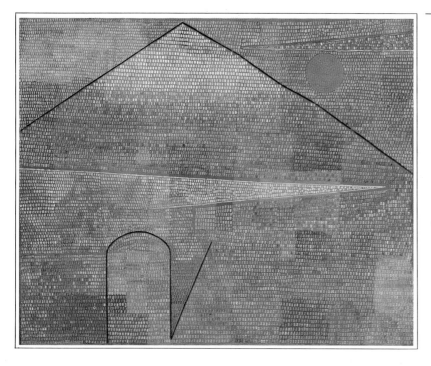

▷ **Ad Parnassum** (details)

KLEE CONSTANTLY astonishes with the range of his techniques and the fecundity of his imagination. This bravura display of tonal variation is breathtaking. The painting has all the qualities of a mosaic, with its brilliant jewel-like colours and the appearance of gold leaf. Klee tended to work on fairly small canvases, but this is one of his larger paintings, being about 1 x 1.25 metres (39 x 49 inches). It testifies to the truth of the observation that he was never happy unless he was working.

△ **Ad Parnassum** 1932

Oil on canvas

THIS IS A BEAUTIFULLY balanced painting, with vibrant colour and superb draughtsmanship. It has qualities of both majesty and mystery and invites extended contemplation. If the Parnassus depicted is the mythological home of the Muses, then it is truly apt that it should also house the Delphic oracle – sacred to the sun god Apollo. Interestingly, there are resonances of the influence of Klee's travels, particularly to Rome, Sicily, Ravenna and even Egypt.

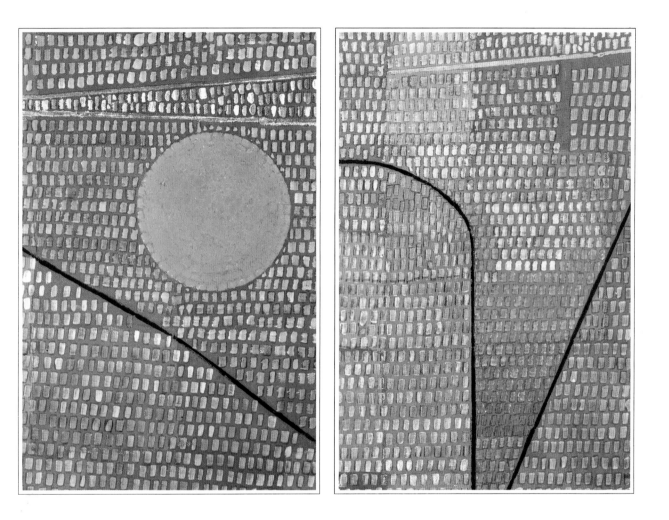

▷ **Insula Dulcamara** 1938

Oil on canvas

AFTER THE SYMPTOMS of Klee's final illness began to take hold, the line in his works noticeably lost its characteristic lightness and boldness, although he never lost his control over it. It began to assume a graphic form reminiscent of Arabic script, perhaps reflecting his interest in Islam, which had always appealed to him. During this period, too, there are graphic suggestions of musical notation. His use of colour became more muted, sometimes sombre. Here the colours are soft, delicate and spring-like on this enchanted island. There is a sense of hope; the plants, although small, are in growth, the ship in the distance is travelling from a dark, sinking constellation towards a light, rising one.

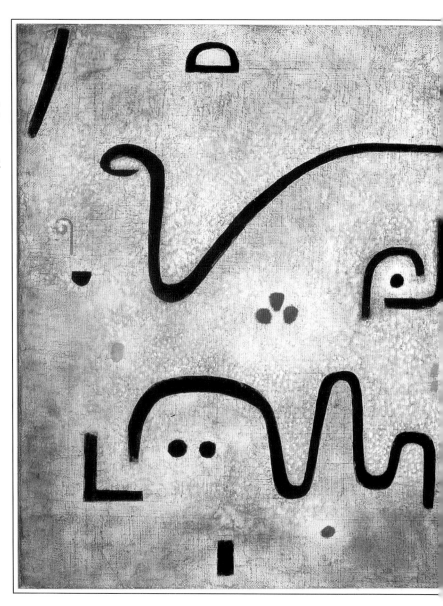

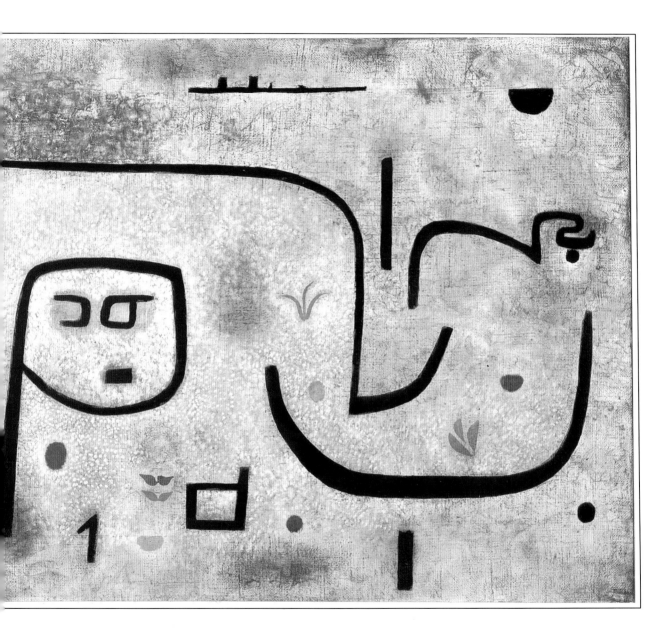

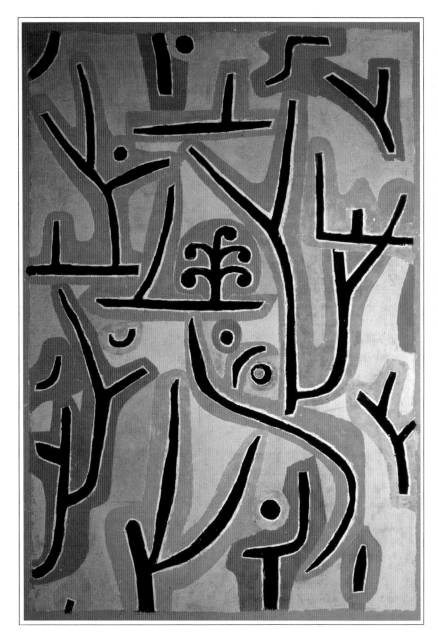

◁ **Park bei Lu** 1938

Oil on canvas

THIS GRACEFUL PAINTING of a park at Lucerne shows no indication of the fear or pain that some other works of Klee's last years reveal. The trees have an elegant mobility and the eye is led to the central conifer. The background colours are luminous and harmonious. This was one of Klee's last paintings in this style and mood. By the following year, his vision of the world, his use of both line and colour and his preoccupying images reflected his knowledge of approaching death.

▷ **Park bei Lu** (detail)

FROM CHILDHOOD ONWARDS a pine tree was a frequently recurring image throughout Klee's work. The central tree here is a curiously life-affirming image, not merely because it is known to be an evergreen. This sturdy, strong specimen seems especially firmly rooted and there is a sense of healthy and, more importantly, continuing growth. The house in which Klee lived in his last years in Berne overlooked a small garden with a pine tree, which brought him especial pleasure.

▷ **Bastard** 1939

THE DARK BACKGROUND and
fat, rounded creature of this
painting have a nightmare
rather than dream-like quality.
Images and symbols of
brutality and corruption,
greed and sexual excess began
to appear in Klee's work from
this year. He tended to use
coarse, rather than the fine
canvases he had previously
favoured. By 1939 he was
ravaged by his illness and
abandoned virtually all his
small pleasures. However, he
continued to work, with a
prolific output, almost until his
death in 1940.

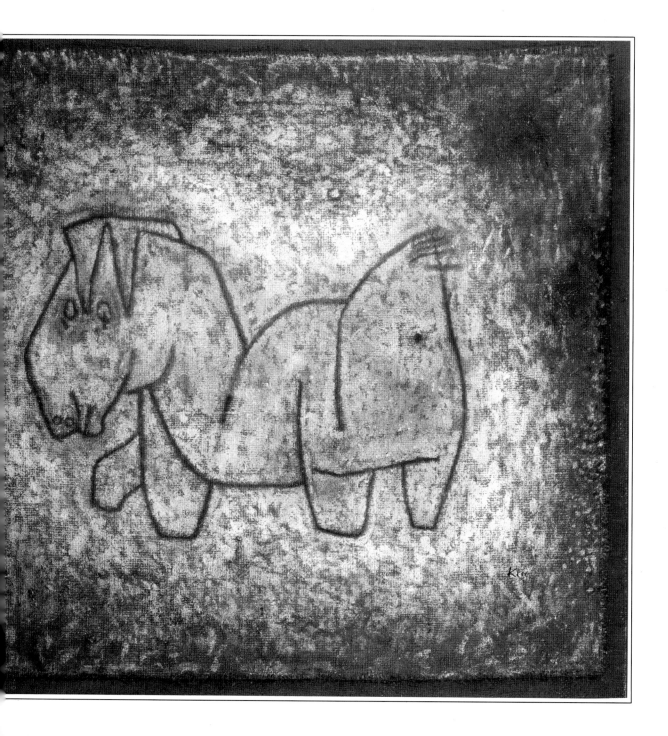

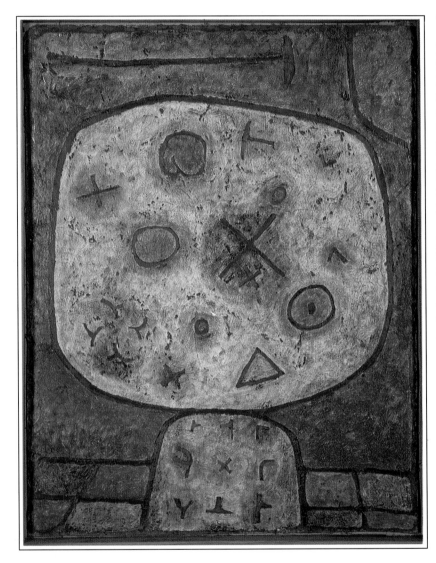

◁ **Flowers in Stone** 1939

IMAGES OF FLOWERS APPEAR throughout Klee's work. Rarely recognizable species, they were more usually flowers of the imagination. In earlier works they were often complex, lyrical and mobile. Here they are painted in brilliant, jewel-like colours and reduced to their essential form. At one stage in his life, Klee took an avid interest in palaeontology and was fascinated by the forms of fossilized plants. This interest clearly informs this painting; all his accumulated experiences provided his inspiration.

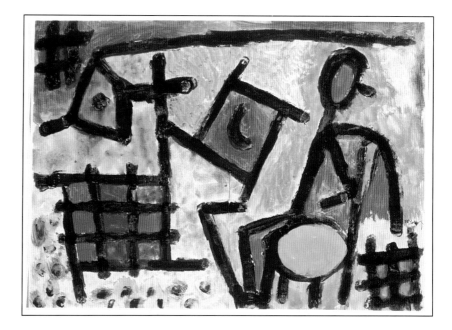

△ **Museale Industrie**

Watercolour

WATERCOLOUR WAS Klee's favourite medium, although he tried virtually every combination of paints, varnish and glue at different times. In fact, his son Felix blames his reckless handling of pigments, some of which contain toxic substances, for causing the illness of which he finally died. Be that as it may, the colour values here have a freshness, simplicity and brilliance that hark back to the early days of Cubism and point forward to the work of Piet Mondrian. The line is bold, even heavy and, once again, favourite images recur – the disc (sun) and crescent (moon) and patterns of grid lines.

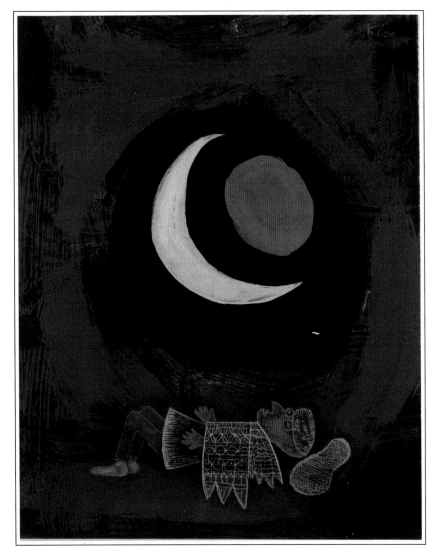

◁ **Sun and Moon**

KLEE FACED the inevitability of his death with the same acceptance of experience that he had shown throughout his life. However, it is interesting how angels became a recurring pictorial theme in these final years. In fact, he wrote the following couplet:

Einst werd ich liegen im Nirgend
Bei einem Engel Irgend.

Characteristically, he included a play on words, which is untranslatable, but the couplet means something along the lines of 'One day I shall lie nowhere/By some angel'.

ACKNOWLEDGEMENTS

The Publisher would like to thank the following for their kind permission to reproduce the paintings in this book:

Bridgeman Art Library, London /Collection Felix Klee, Bern: 8-11, 74; /**Stadtische Galerie im Lenbachhaus, Munich:** 12-13, 17; /**Kunstmuseum, Basle:** Cover, Half-title, 14-15, 37; /**Christie's, London:** 18-20, 22, 25, 35, 40-41, 46-47, 52-53, 56-57, 59-65, 67, 77; /**Museum of Modern Art, New York:** 21; /**Kunstmuseum, Hanover:** 23, 42-43; /**Mayor Gallery, London:** 24; /**Nordiska Museet, Stockholm:** 27; /**Staedel Institute, Frankfurt:** 28-29; /**Tate Gallery, London:** 31, 34; /**Private Collection:** 32-33, 50-51, 78; /**Galerie Slang, Munich:** 38-39; /**Museo Ca Pesaro, Venice:** 44-45; /**Kunsthalle, Hamburg:** 48-49; /**Grosvenor Gallery, London:** 54; /**Guggenheim Collection, Venice:** 58; /**Kunstmuseum, Bern:** 68, 69 right, 69 left, 72-73; /**Photo: Archiv fur Kunst und Geschichte, Berlin:** 70-71; /**Galerie Rosengart, Lucerne:** 76;